FICTIONALLY FABULOUS

THE CHARACTERS WHO
CREATED THE LOOKS WE LOVE

WRITTEN AND ILLUSTRATED BY
ANNE KEENAN HIGGINS

RUNNING PRESS
PHILADELPHIA

Page 1: Carrie Bradshaw, *Sex and the City*, 1998–2004
Page 2: Cher Horowitz, *Clueless*, 1995
Page 4: Holly Golightly, *Breakfast at Tiffany's*, 1961
Page 5: Lulu, *Pandora's Box*, 1929

Published by Running Press, an imprint of Perseus Books, LLC.,
a subsidiary of Hachette Book Group, Inc.

Books published by Running Press are available at special discounts
for bulk purchases in the United States by corporations, institutions,
and other organizations. For more information, please contact the
Special Markets Department at Perseus Books, 2300 Chestnut Street,
Suite 200, Philadelphia, PA 19103, or call (800) 810-4145, ext. 5000,
or e-mail special.markets@perseusbooks.com.

ISBN 978-0-7624-6142-4
Library of Congress Control Number: 2016955165

E-book ISBN 978-0-7624-6143-1

9 8 7 6 5 4 3 2 1
Digit on the right indicates the number of this printing

Designed by Anne Keenan Higgins and Amanda Richmond
Edited by Cindy De La Hoz
Typography: Adobe Caslon and Neutra Text

Running Press Book Publishers
2300 Chestnut Street
Philadelphia, PA 19103-4371

Visit us on the web!
www.runningpress.com

To my awe-inspiring
parents, Jack and Ellen

CONTENTS

INTRODUCTION

HAVE YOU EVER STARTED WATCHING A FILM OR TELEVI-
sion show, and before you know it, you have become totally
transfixed by what the characters are wearing instead of what
they are saying? It happens to me all the time. I'll have to go
back and rewind for the story, but that also gives me another
opportunity to see that beautiful black satin gown or the intri-
cate beading on an evening clutch. Over the years, there have
been ensembles that literally take my breath away—Audrey
Hepburn as Jo Stockton from *Funny Face*, magically floating
down the steps of the Louvre in a red strapless gown holding a
chiffon scarf high up over her head, or Sarah Jessica Parker as
Carrie Bradshaw in *Sex and the City*, finally being told by Mr.
Big that "she's the one" in her ethereal vintage mint-green tulle
ballerina dress.

In illustrating and writing this book, I wanted to convey the importance of a costume designer's role and to acknowledge the impact they have had on the fashion trends that women have followed for the past one hundred years. Then, of course, there are the characters themselves, from Holly Golightly's carefree elegance to Laura Petrie's endearing perkiness and Annie Hall's naïve charm. Those characters became iconic when the actresses themselves stepped into their little black dresses, bell-bottom pants, or sky-high stilettos. *Fictionally Fabulous* is a tribute to the designers, the characters, and the actresses who for the past century have captivated us with their originality, innovation, and style.

Lulu

OPEN PANDORA'S BOX AND YOU'LL FIND THE FREE-SPIRITED Lulu happily dancing in a white breezy chiffon dress with long, flowing sleeves. Her legendary black bob, perfect bangs, and beguiling smile captivates everyone she meets. Over the course of the story, Lulu goes from a V-neck white satin wedding dress to a dramatic long-sleeve black high-neck silk dress with veil as she stands trial for murder. While on the run, she wears a sexy, sheer, low-cut lace tank dress adorned with a small brooch at the hip. Trouble hits yet again and only Lulu can pull off a men's black-and-white striped T-shirt with sailor pants. And even when Lulu has hit rock bottom and is about to meet her demise, her style prevails as she wears a silk Peter Pan collared tied blouse accented with small studs on the cuffs and waist.

Pandora's Box, 1929
Louise Brooks as Lulu
Costume Designers: Jean Patou
and Gottlieb Hesch

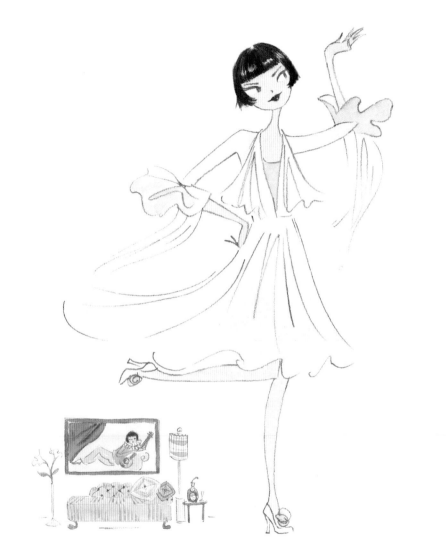

Helen Faraday

AS A DEVOTED WIFE AND MOTHER FORCED BACK INTO performing, Helen Faraday (aka Helen Jones) emerges from a gorilla suit and dons a wicked platinum-blonde curly wig with sparkly arrows sticking every which way. Singing the infamous song, "Hot Voodoo," she immediately catches the eye of millionaire Nick Townsend. On and off the stage, Helen dazzles with fur-trimmed dresses and coats, a tailored riding jacket topped off with a derby hat, and gowns adorned with shimmering beading. The most iconic and memorable ensemble is the androgynous white tuxedo accented with rhinestones and matching top hat. Townsend tells her "a little of you is worth a lifetime with any other woman." That statement couldn't be truer when it comes to the sultry style of Blonde Venus.

Blonde Venus, 1932
Marlene Dietrich as Helen Faraday
Costume Designer: Travis Banton

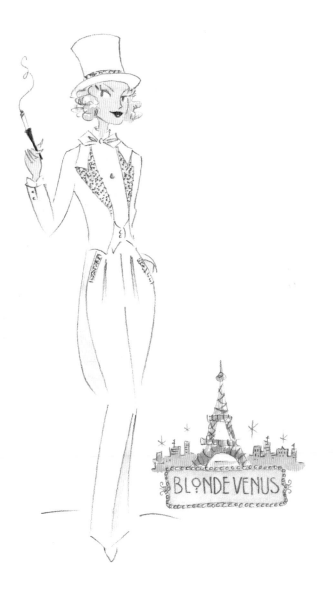

Tracy Lord

AS PRIVILEGED SOCIALITE TRACY LORD PREPARES FOR her second wedding, she's seen at turns wearing perfectly tailored pantsuits, an art deco gold sequin beaded silk gown with fitted buttoned cuffs, and an over-the-top gingham three-tiered skirt. Costume designer Adrian successfully portrayed her image as a Greek goddess, untouchable in a belted long swimming gown covering a sleek and simple striped one-piece swimsuit. "Red," as she's referred to by her first husband, continues to dazzle in a flowing organza-layered, collared wedding gown accented with an obi-styled belt and topped off with an oversize wide-brim hat featuring long ribbons. With three men infatuated with her independence, smarts, and beauty, the stylish Miss Lord finally gets the man she wants and a dreaded full-page spread in the gossip magazine, *Spy*, for all the world to see.

The Philadelphia Story, 1940
Katharine Hepburn as Tracy Lord
Costume Designer: Adrian

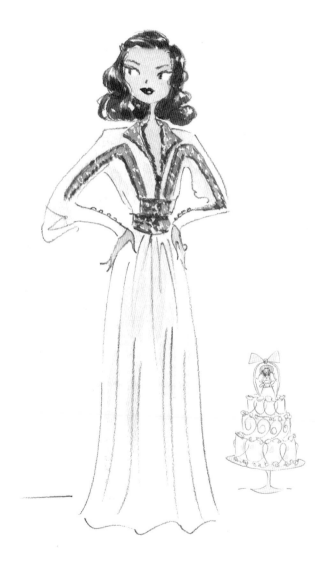

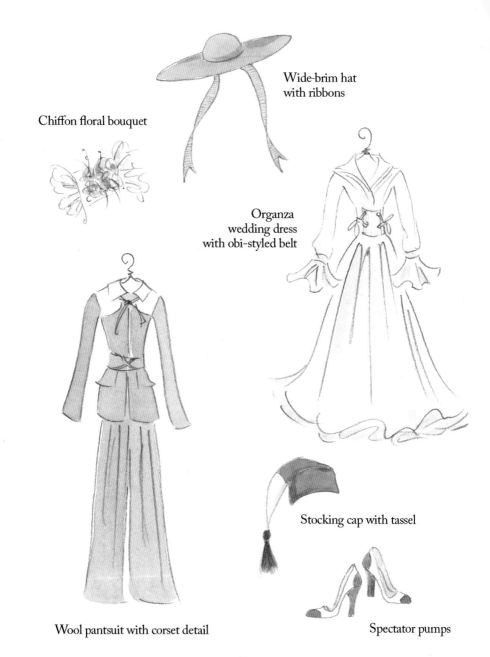

Wide-brim hat
with ribbons

Chiffon floral bouquet

Organza
wedding dress
with obi-styled belt

Stocking cap with tassel

Wool pantsuit with corset detail

Spectator pumps

Diamond chain bracelet

Tortoise
hair comb

Princess cut diamond
engagement ring

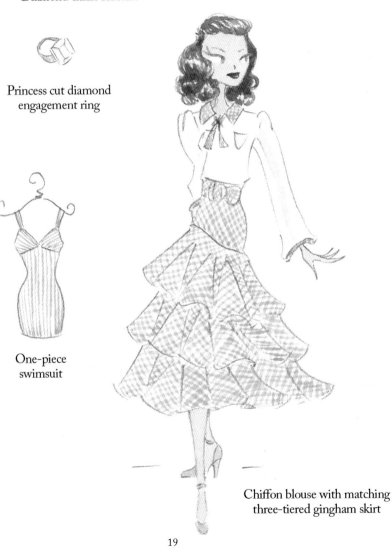

One-piece
swimsuit

Chiffon blouse with matching
three-tiered gingham skirt

Vivian Rutledge

IN THIS COMPLEX MYSTERY THRILLER, HEIRESS VIVIAN
Rutledge has the confidence and smoldering style that allows
her to wrap any man around her finger. In her first encounter
with Detective Marlowe, who's been hired to get her little sis-
ter out of a jam, she's wearing a buttoned, brushed velvet coat,
sweater, trousers, and loafers. From there, the sparks fly between
the two and so do her ensembles, from a silk charmeuse robe as
she strides down the hallway of her father's mansion to a lamé
evening jacket when she meets Marlowe again for some sexy
banter at a nightclub. But the most memorable outfit is Vivi-
an's black-and-white houndstooth wool suit, worn with a crew
neck and a black beret. Even with all the thugs, gamblers, and
blackmailers in Vivian's complicated life, she eventually escapes
trouble all the while maintaining her effortless glamour.

The Big Sleep, 1946
Lauren Bacall as Vivian Rutledge
Costume Designer: Leah Rhodes

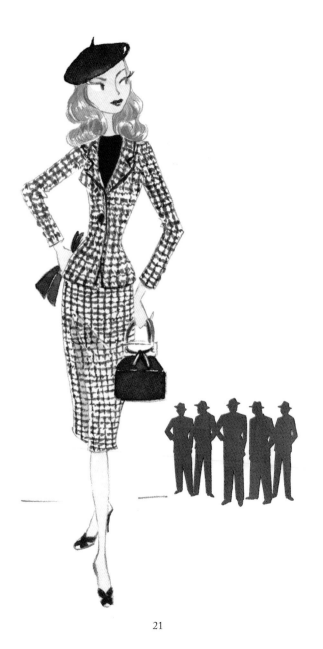

Gilda

"ME?" YES, YOU GILDA. WITH A FLIP OF HER HAIR AND a suspiciously innocent off-the-shoulder chiffon dressing gown, Gilda captivates the audience the moment she appears on-screen. Running from Buenos Aires to Montevideo to escape her controlling husband, she sparkles while performing in a two-piece midriff baring, backless white-and-gold beaded gown. Desperate to be the good girl in her Grecian-inspired dresses, she's forced to be the bad girl as she goes from one strapless stunner to the next. The showstopper, of course, is the iconic black satin strapless side-slit gown with side bow, matching elbow black gloves, and diamond choker—an ensemble that became responsible for one of the absolute best fashion moments in film.

Gilda, 1946
Rita Hayworth
as Gilda Mundson Farrell
Costume Designer: Jean Louis

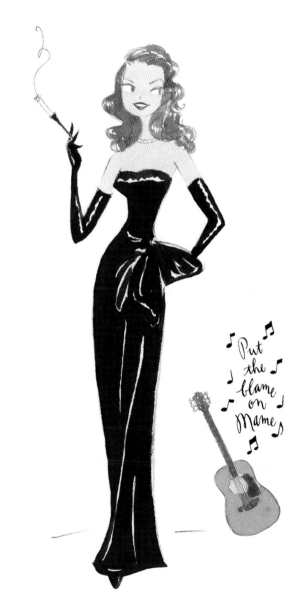

Put
the
blame
on
Mame

Beaded gold dress Beaded sequin opera coat

Leather studded
belt with
matching cuff

Beaded satin stilettos

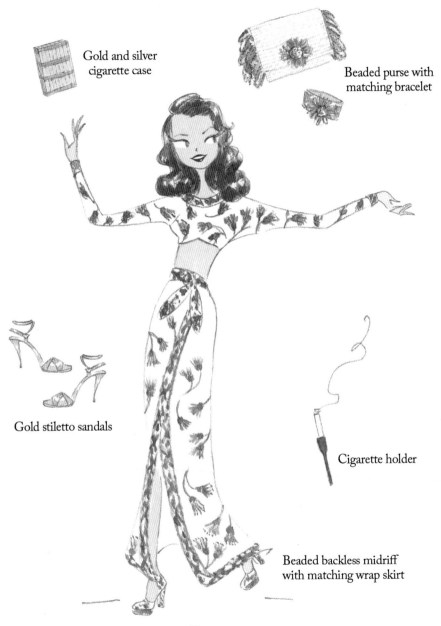

Gold and silver
cigarette case

Beaded purse with
matching bracelet

Gold stiletto sandals

Cigarette holder

Beaded backless midriff
with matching wrap skirt

Lucy Ricardo

ONE OF THE FUNNIEST HOUSEWIVES IN TV HISTORY, LUCY Ricardo also entertains with her wardrobe of polka-dot and gingham-patterned dresses and tops. While cooking, cleaning, or looking after Little Ricky, her appliquéd and embroidered aprons keep her contrasting collar-and-cuff flare dresses clean. For a more casual look, she'll wear a tapered ankle-length pant with a striped sweater and ballet flats. As she spends an afternoon desperately trying to meet a very famous celebrity, she shines in a rhinestone-encrusted sheer polka-dot housecoat and cigarette pants. And even when strolling the streets of Paris with her best friend, Ethel, in faux couture Jacques Marcel potato sack dresses, we still love Lucy.

I Love Lucy, 1951–1957
Lucille Ball as Lucy Ricardo
Costume Designers: Edward Stevenson and Elois Jenssen

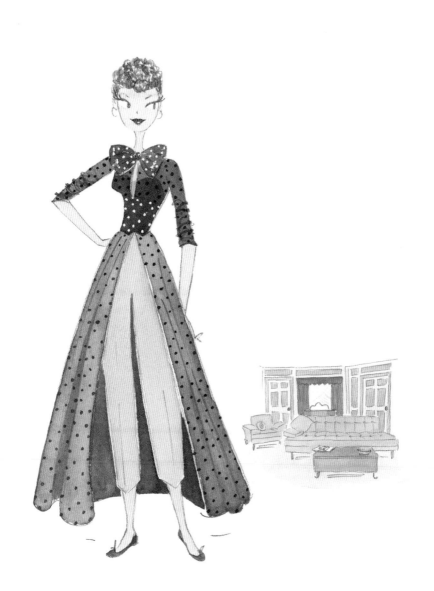

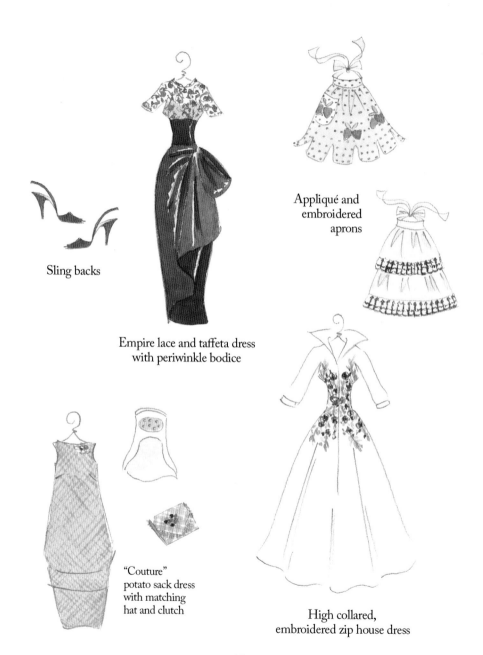

Sling backs

Appliqué and
embroidered
aprons

Empire lace and taffeta dress
with periwinkle bodice

"Couture"
potato sack dress
with matching
hat and clutch

High collared,
embroidered zip house dress

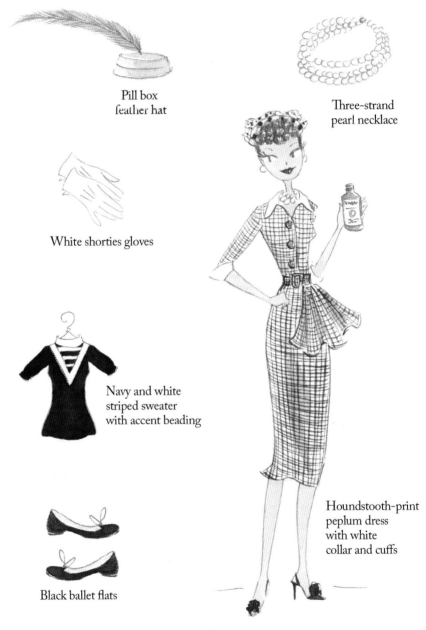

Pill box
feather hat

Three-strand
pearl necklace

White shorties gloves

Navy and white
striped sweater
with accent beading

Houndstooth-print
peplum dress
with white
collar and cuffs

Black ballet flats

Lisa Fremont

IN SCENE AFTER SCENE, HIGH-FASHION MODEL LISA CAROL Fremont dazzles with elegance, class, and style. She enters her photographer boyfriend L.B. "Jeff" Jeffries's apartment in a stunning black-and-white full-skirt dress accessorized with a pearl choker, pearl bracelet, white gloves, a chiffon wrap, and strappy heels. Every outfit is expertly styled and she knows exactly what to wear at precisely the right time—from a green linen business-like suit as she describes her theory as to why the neighbor across the way may have murdered his wife, to the floral sleeveless day dress she wears while climbing a fire escape into the murderer's apartment. Even after the mystery is solved and Lisa sits relaxing with a good book (and eventually *Bazaar* magazine), she still exudes an effortlessly fashionable look in a simple coral oxford shirt, cuffed jeans, and loafers.

Rear Window, 1954
Grace Kelly as Lisa Fremont
Costume Designer: Edith Head

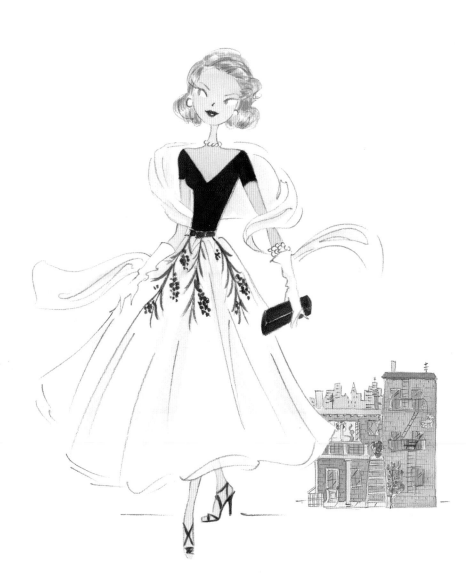

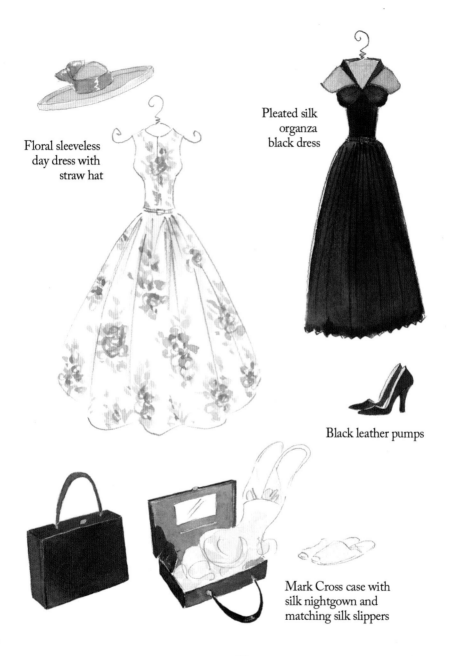

Floral sleeveless
day dress with
straw hat

Pleated silk
organza
black dress

Black leather pumps

Mark Cross case with
silk nightgown and
matching silk slippers

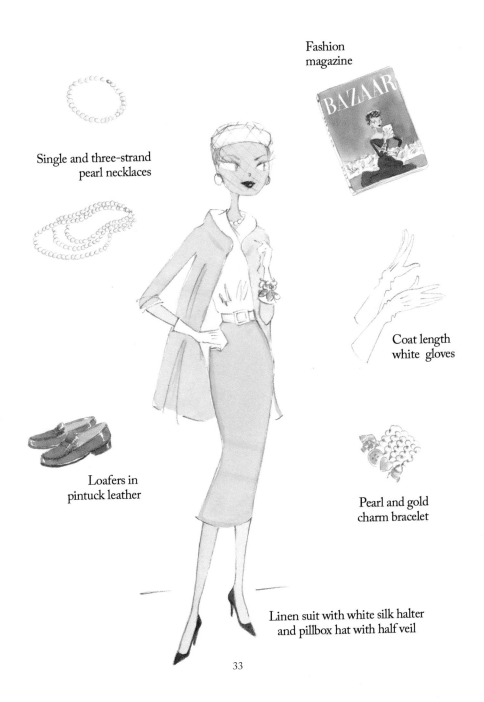

Fashion magazine

Single and three-strand pearl necklaces

Coat length white gloves

Loafers in pintuck leather

Pearl and gold charm bracelet

Linen suit with white silk halter and pillbox hat with half veil

BAZAAR

The Girl

IT'S A HOT SUMMER IN MANHATTAN AND EVERYONE IS itching to get out of the city—everyone but a gorgeous blonde and her neighbor, Richard, a faithful husband and middle-aged publishing exec. When he invites The Girl over for a drink, she saunters through the door in a sexy, strapless tiger-print gown with sequined evening gloves. However, the dress is only a fantasy in Richard's mind and instead we see her in an innocent cotton candy–pink blouse cinched at the waist with a belt, matching capris, and white sandals. As cocktails turn to bubbles, The Girl decides to change into a white sequin dress with crisscross straps in the front. And in what becomes one of the most iconic moments in film history, The Girl cools off by standing on a subway grate as a train below rushes through, blowing up her ivory halter pleated dress with a thin self-belt wrapped around the torso, crossing in the front and then tied in a bow at the waist. It's a vision that can only be described as *"delicious!"*

The Seven Year Itch, 1955
Marilyn Monroe as The Girl
Costume Designer: Travilla

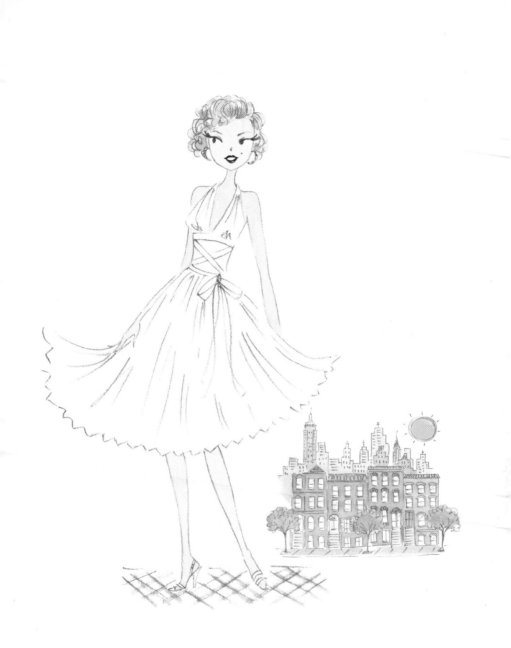

Francie Stevens

WHILE VACATIONING WITH HER MOTHER IN ONE OF THE world's fashion capitals, Cannes, Francie Stevens catches the attention of legendary jewel thief John Robie (aka The Cat) in an ice-blue chiffon gown accented with a coordinating blue chiffon scarf and matching evening bag. As the two play a game of cat and mouse, she slips into one sensational ensemble after another. Meeting John for a swim, Francie makes a splash in a drawstring skirt, halter top, capri pants, turban, and crownless hat. She changes into a coral-pink swirl-patterned top, full skirt, pink chiffon scarf, and white leather driving gloves as the two take a wild ride through the winding roads of the Riviera. Sparks fly as Francie seduces John in a white strapless column gown and a sparkling faux diamond necklace. But where Francie really shines is at a masquerade ball in a gold lamé gown, diamond choker, and golden wig adorned with fabric birds. In this stunning ensemble she lends a hand to the wrongly accused Robie as they catch the kitten pretending to be The Cat.

To Catch a Thief, 1955
Grace Kelly as Francie Stevens
Costume Designer: Edith Head

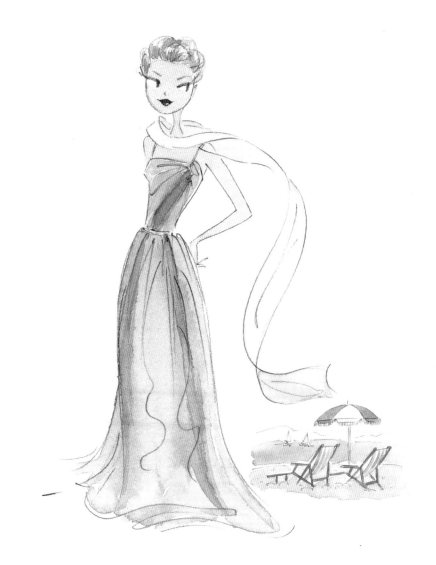

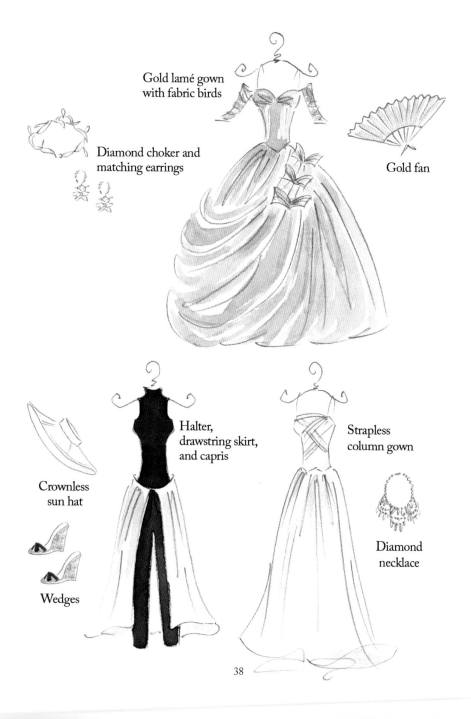

Gold lamé gown
with fabric birds

Diamond choker and
matching earrings

Gold fan

Crownless
sun hat

Halter,
drawstring skirt,
and capris

Strapless
column gown

Wedges

Diamond
necklace

38

White leather
driving gloves

Evening clutch

Gold hoop handle
day handbag

Beach turban and
white sunglasses

Roundneck crepe sweater,
pleated skirt, silk scarf, and
slingback shoes

Jo Stockton

THE BOOKISH JO STOCKTON IS DISCOVERED WHILE WORK-
ing in a New York City philosophy bookstore. Jo is really more of
a "thinker," but this reluctant model has the pizzazz the fashion
world is waiting for. Once in Paris, Jo dazzles in one Givenchy
creation after another—on the runway in a pink cloak, cream
satin full-length dress, evening gloves, and a diamond head-
piece; holding a dozen balloons wearing a little black dress and
hat; and catching a fish along the Seine in a straw hat, cropped
coat, cigarette pants, and a pink scarf tied around the waist.
And as Jo floats down the steps of the Louvre, she dazzles in a
memorable red strapless gown holding a chiffon scarf up over
her head. Jo finds herself falling in love with photographer
Dick Avery, but after an argument things get overblown and
a beautiful strapless embroidered dress gets soaked. However,
Jo realizes she was wrong and she finds her love in a full bal-
lerina-skirt, drop-waist bodice and two-tiered veil with a small
white bow. "'S wonderful! 'S marvelous!" Indeed!

Funny Face, 1957
Audrey Hepburn as Jo Stockton
Costume Designer: Hubert de Givenchy

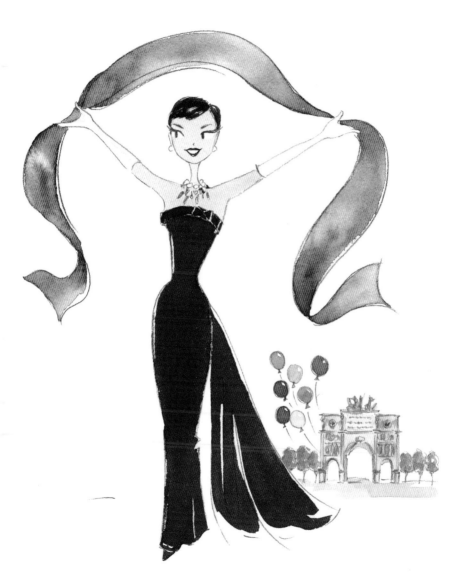

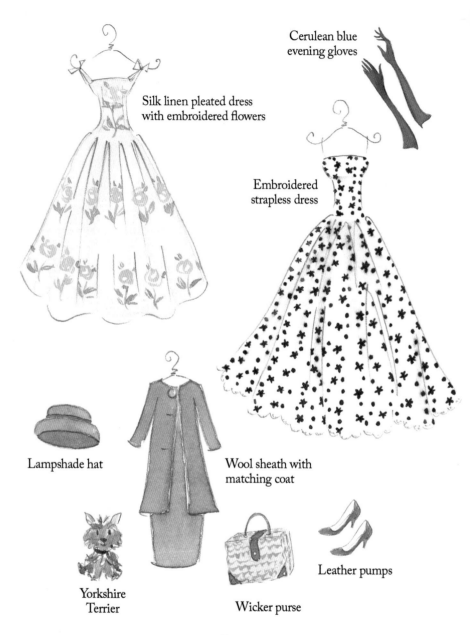

Cerulean blue
evening gloves

Silk linen pleated dress
with embroidered flowers

Embroidered
strapless dress

Lampshade hat

Wool sheath with
matching coat

Yorkshire
Terrier

Wicker purse

Leather pumps

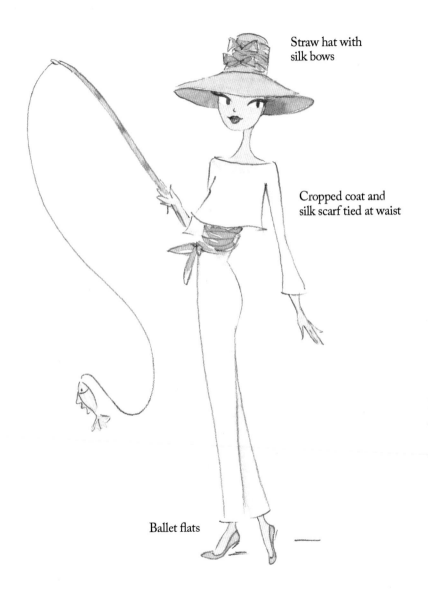

Straw hat with
silk bows

Cropped coat and
silk scarf tied at waist

Ballet flats

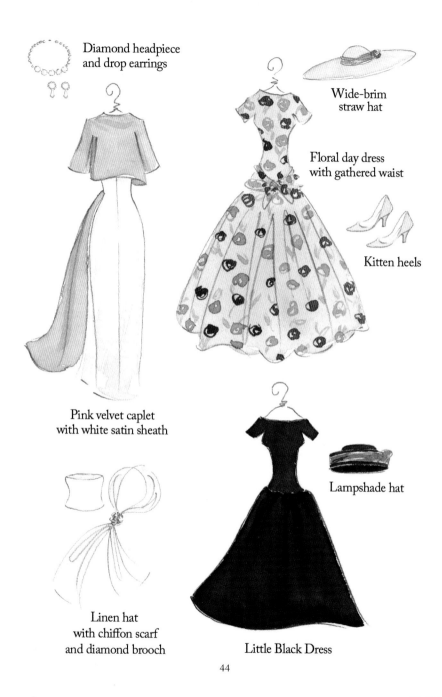

Diamond headpiece
and drop earrings

Wide-brim
straw hat

Floral day dress
with gathered waist

Kitten heels

Pink velvet caplet
with white satin sheath

Lampshade hat

Linen hat
with chiffon scarf
and diamond brooch

Little Black Dress

44

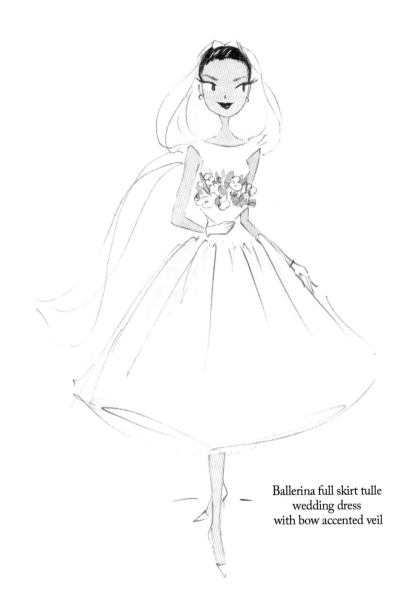

Ballerina full skirt tulle
wedding dress
with bow accented veil

Patricia Franchini

PATRICIA FRANCHINI, AN AMERICAN STUDENT AND ASPIR-
ing journalist living in Paris, leaves us *breathless* with her gamine
pixie haircut and charming Parisian style. We first see her walk-
ing up and down the Champs-Élysées with her cop-killing,
car-thieving boyfriend Michel, wearing the iconic New York
Herald-Tribune ribbed T-shirt, cigarette pants, and flats. The
two part ways and meet up later, with Patricia wearing a classic
Breton striped top and pleated skirt. During a lazy afternoon,
Patricia lounges with Michel in a striped tank, white shorts, a
borrowed trilby hat, and eventually, his pinstriped shirt. Soon
after their liaison, she is off to a press conference but wants
to buy something new and finds a memorable striped, belted,
short-sleeved dress with an oversized collar, white gloves,
white pumps, and mod cat-eyed sunglasses. Unfortunately, this
doomed love affair is cut short when the police question Patri-
cia and pressure her into turning in her impudent boyfriend.
Even as she wistfully watches Michel run from the police and
bid his fatal adieu, her effortless chic is pure *je ne sais quois*.

***Breathless*, 1960**
Jean Seberg as Patricia Franchini
Jean Seberg's personal wardrobe

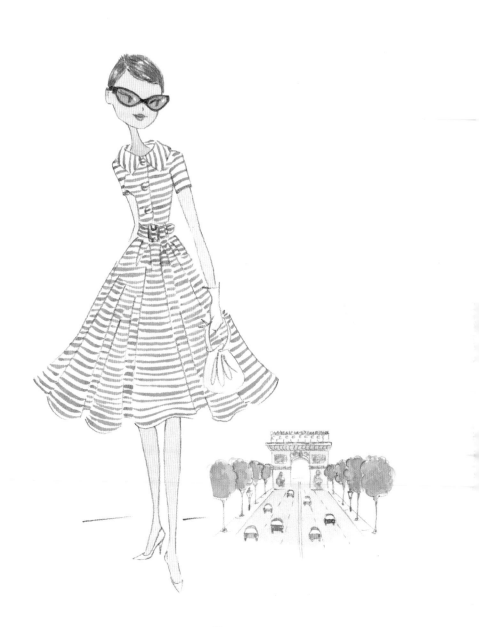

Holly Golightly

CAFÉ-SOCIETY GIRL HOLLY GOLIGHTLY'S STYLE IS ELE-
gant, simple, and iconic. Her Givenchy little black dress became
the must-have for cocktail parties and a night out on the town.
History was made when Holly is seen strolling toward Tiffany
& Co. at five in the morning in her trademark oversize tortoise-
shell sunglasses, white scarf, black evening gown, long black
satin gloves, pearl strand necklace, and diamante hair accessory.
Her bouffant French twist set yet another fashion trend, and
only Holly could make a man's tuxedo shirt worn as a night-
shirt look fashionable. Later, with her wide-brimmed hat, khaki
trench coat, kitten heels, and leather tote, Holly epitomizes
classic glamour and inspires women everywhere.

Breakfast at Tiffany's, 1961
Audrey Hepburn as Holly Golightly
Costume Designer: Hubert de Givenchy

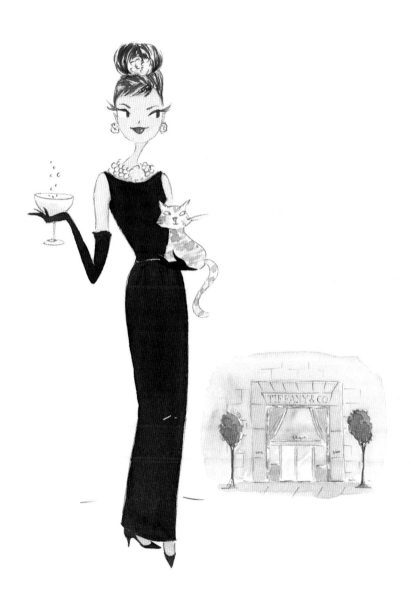

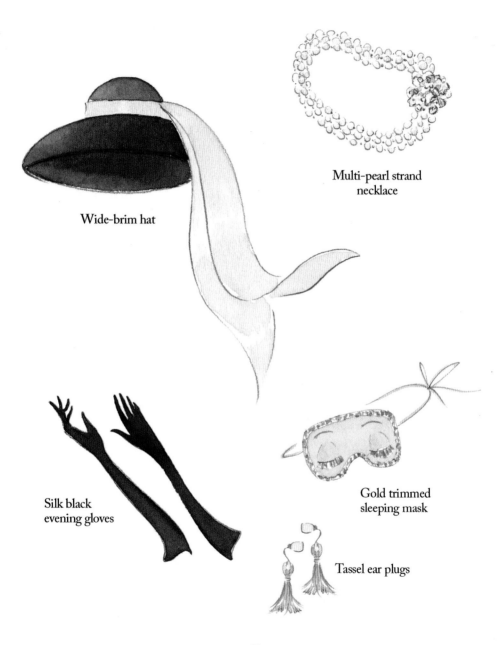

Wide-brim hat

Multi-pearl strand
necklace

Silk black
evening gloves

Gold trimmed
sleeping mask

Tassel ear plugs

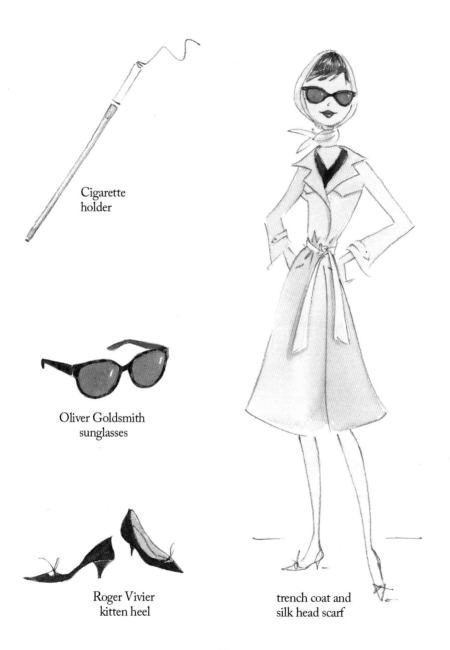

Cigarette holder

Oliver Goldsmith sunglasses

Roger Vivier kitten heel

trench coat and silk head scarf

Laura Petrie

IN AN ERA WHEN TV HOUSEWIVES WERE EXPECTED TO wear dresses around the house, Laura Petrie's signature cigarette pants set a whole new trend. She completes the ensemble with a simple pullover top accented with pearls or a rhinestone brooch. When she does bare her legs, it's with a kicky dress or full pleated skirt. Her mock turtlenecks, Peter Pan–collared dresses and tie-neck blouses are modeled after Jackie Kennedy, as is her bouffant hairstyle. Occasionally she dials it up a notch with a patterned hostess jacket worn over metallic brocade pants and matching silver shoes or a spaghetti-strap party dress with matching kitten heels. Even with her disastrous mishap as a half-blonde-haired brunette, Laura Petrie still wows audiences with her perky, classic American style.

The Dick Van Dyke Show, 1961–1966
Mary Tyler Moore as Laura Petrie
Costume Designers: Harald Johnson
and Marge Makau

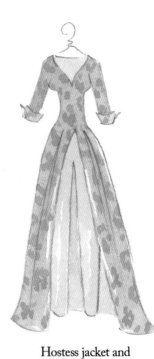

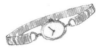

Gold bracelet watch

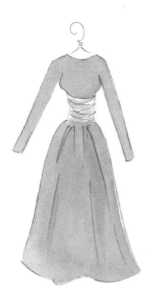

Wool dress
with chiffon waist

Hostess jacket and
metallic brocade pants

Brown leather flats

Tunic with fringe

Scarf collared tunic

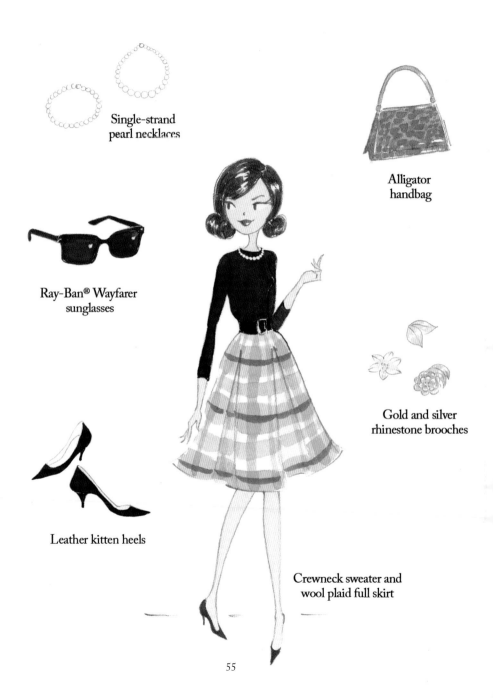

Single-strand
pearl necklaces

Alligator
handbag

Ray-Ban® Wayfarer
sunglasses

Gold and silver
rhinestone brooches

Leather kitten heels

Crewneck sweater and
wool plaid full skirt

Bond Girls

PUSSY GALORE, TIFFANY CASE, MAY DAY, HOLLY GOOD-head, and Jinx Johnson are just a few of the elite group that make up the famous Bond Girls. With their plunging necklines, thigh-high split dresses, and mesh swimsuits, they know exactly how to work it when fighting for or against special agent James Bond. Honey Ryder sizzles in a knife-strapping, two-piece swimsuit that became the most iconic bikini of all time and sold at auction for around $60,000. The icy Miranda Frost, in a luminous crystal-encrusted gown, brainy Dr. Madeleine Swann wearing a Lover Venus lace dress with Jimmy Choo sandals, and seductress Vesper Lynd in a Versace black gown with a strapped back and fishtail skirt are just a few fashion highlights of 007's femme fatales. Even the doomed Shirley Eaton looked luminous wearing nothing but a layer of gilded gold. Whether they're in a gunfight, a karate-kick, or simply sipping a martini, they are all hardly ever shaken and never stirred.

James Bond Series: *Dr. No*, 1962; *Goldfinger*, 1964; *Diamonds Are Forever*, 1971; *Die Another Day*, 2002; and *Casino Royale*, 2006

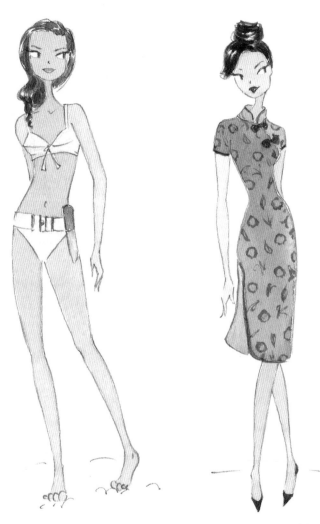

Ursula Andress as Honey Ryder
Costume Designer:
Tessa Welborn

Zena Marshall as Miss Taro
Costume Designer:
Tessa Welborn

Honor Blackman as Pussy Galore
Costume Designer: Elsa Fennell

Jill St. John as Tiffany Case
Costume Designer: Don Feld

Rosamund Pike as Miranda Frost
Costume Designer:
Lindy Hemming

Eva Green as Vesper Lynd
Costume Designer:
Lindy Hemming

Ginger Grant

GINGER GRANT IS THE QUINTESSENTIAL HOLLYWOOD glamour gal. While still wearing a Nolan Miller beaded evening gown, the movie star sets sail for a three-hour tour. After disaster strikes, she is stranded on a deserted island with nothing but the dress she performed in only moments before boarding the S.S. *Minnow*. With the help of Lovey Howell's expensive hand-me-down wardrobe, Miss Grant handily stitches together stunning ensembles of sparkly gowns and separates. Among the favorites is her white glitter gown, off-the-shoulder leopard dress, and Hawaiian print bandeau top with matching skirt. But one of her more mod ensembles—green turtleneck, brown corduroy cigarette pants, and white go-go boots—is a showstopper while performing with the short-lived girl group, the Honeybees.

Gilligan's Island, 1964–1967
Tina Louise as Ginger Grant
Costume Supervisor: Robert Fuca
Wardrobe: Frank Delmar

Ann Marie

ASPIRING ACTRESS ANN MARIE MOVES INTO HER FIRST New York City apartment and fills her closet with Technicolor mod mini dresses and edgy outfits by designers Cardinali, Halston, Mary Quant, and Oscar de la Renta. Introducing a British influence with big sunglasses, fishnets, and white boots, she runs from one acting audition to the next or meets her boyfriend Donald for dinner and a movie. Her flip-hairdo and big eyelashes (which she doubled) became as iconic as the pink *That Girl* kite she flies through Central Park. When Ann dresses up for a special evening, a little asymmetrical dress with a ruffle trim and matching shorts are a showstopper. With her color-blocking mini dresses; fringe vest; plaid pants; calico printed skirts; and red, white, and blue scarves, "she's the girl that every girl should be," she's *That Girl*.

That Girl, 1966–1971
Marlo Thomas as Ann Marie
Costume Designers: Phyllis Garr,
Fern Vollner, Suzanne Smith,
and Florence Albert

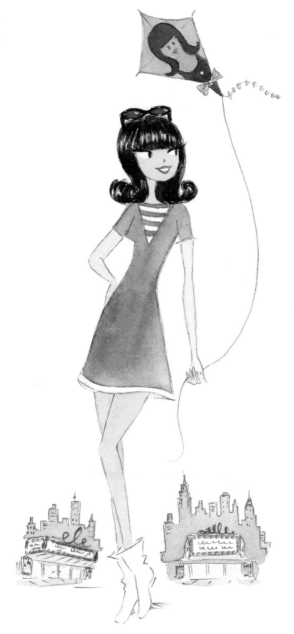

Séverine Serizy

FOR A BORED, WEALTHY PARISIAN HOUSEWIFE, SÉVERINE Serizy has a very active imagination. Her erotic fantasies take her where two men are tearing off her classic red "Eisenhower"-style double-breasted jacket with brass buttons and matching dress. As her reveries change, so does her timeless Yves Saint Laurent wardrobe. Wearing a buttery-brown leather double-breasted coat with fur-trimmed cuffs, pockets, and collar, she becomes intrigued about the news of a high-class brothel where she feels the need to make inquiries. Maintaining her controlled persona, Séverine shows up on the doorstep of Madame Anais in a tailored gray double-breasted coat with epaulettes, wide-set collar, and a black pillbox wool hat. But after leading a double life and suddenly needing to take care of her husband, she appears in a prim black mid-length shirt dress with white silk collar and French cuffs paired with black suede scalloped-edge pumps. Soon this *belle de jour* settles back into a life she's accustomed to and continues on with her sophisticated and fashion-forward style.

Belle de Jour, 1967
Catherine Deneuve as Séverine Serizy
Costume Designer: Yves Saint Laurent

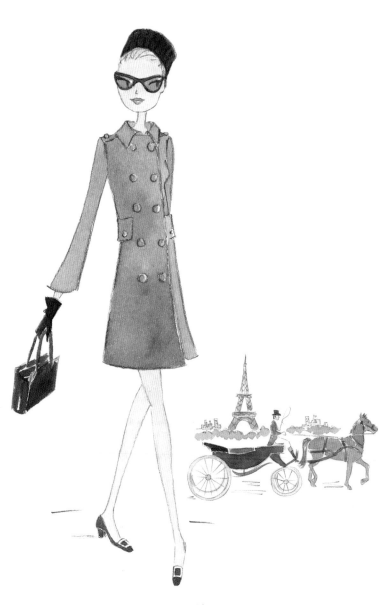

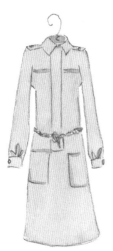

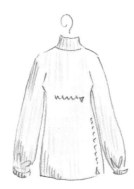

Wool zipper
ski sweater

Black patent leather
Roger Vivier pumps

Wool dress with hidden
zip and gold chain belt

Brown leather
Roger Vivier pumps

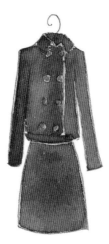

Red "Eisenhower"
jacket and dress

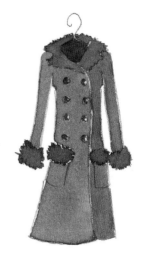

Brown fur-timmed
leather coat

Fur and leather
studded hat

Black leather
handbag with
gold accent

Wraparound
tortoise sunglasses

Tortoise hairpins

Guerlain Mitsouko
perfume

Black suede
scalloped pumps

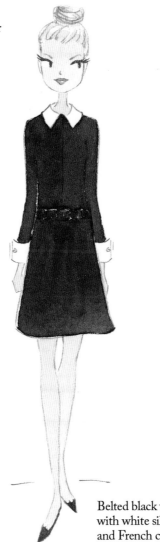
Belted black wool dress
with white silk collar
and French cuffs

Bonnie Parker

WHEN POOR SOUTHERN GIRL BONNIE PARKER FIRST LAYS eyes on bad boy Clyde Barrow, she knows she's found her ticket out of dulls-ville. In her signature berets, pencil skirts, knitted sweaters, and silk scarves, Bonnie becomes the most stylish outlaw in a 1960s spin on '30s fashion. This hotheaded, gun-toting bank robber needs a comfortable wardrobe to out-run the coppers, but never has to compromise on style. From a belted black-and-white windowpane print suit to a knitted sweater, or tweed skirt with printed scarf, her ensembles inspired a generation of fashion designers. Even Bonnie's golden-bobbed hair had women lobbing off their locks to get the look. Wearing a red-checked dress with a white collar and white-buttoned cuffs, she reads a poem she wrote telling the story of her adventures with Clyde. And when Bonnie is seen in an angelic cream-colored day dress with a tie back, delicate embroidery across the front, and a .38 special revolver taped to her thigh, she comes to her inevitable demise "by a sub-gun's rat-tat-tat."

Bonnie and Clyde, 1967
Faye Dunaway as Bonnie Parker
Costume Designer: Theadora Van Runkle

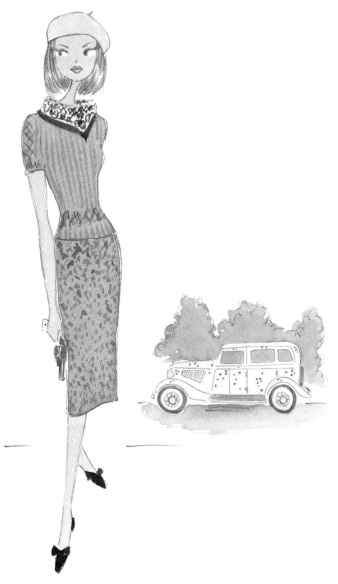

Jenny Cavalleri

RADCLIFFE MUSIC MAJOR JENNY CAVALLERI HAS A TIME-less style and beauty that captures the heart of preppy Oliver Barrett. Her black wool peacoat, paired with various cashmere scarves and hats, is the wardrobe star of the film. When Jenny meets the stuffy billionaire in-laws-to-be, she illuminates the room in a red silk cocktail dress with a wide waistband that ties at the side. Later, she breaks up a barren winter setting in a red turtleneck, wide black belt, and red tartan plaid skirt as she's carried over the threshold of the Barretts's cozy new apartment. The only summer outfit Jenny wears is a classic navy crewneck T-shirt with "Camp Tuckahoe" printed across the front and pairs it with white low-slung denim jeans. And when she sniffles through her classic line, "Love means never having to say you're sorry," she still looks fabulous wearing a black turtleneck, wide belt, taupe gathered skirt, and black tights. The wardrobe of this tragic *love story* introduced the world to preppy and continues to influence designers today.

Love Story, 1970
Ali McGraw as Jenny Cavalleri
Costume Designers: Alice Manougian
Martin and Pearl Somner

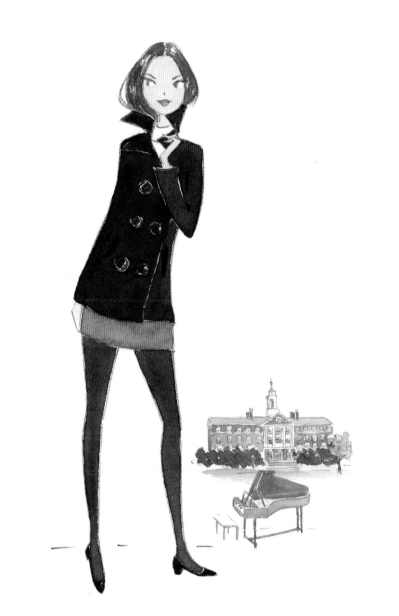

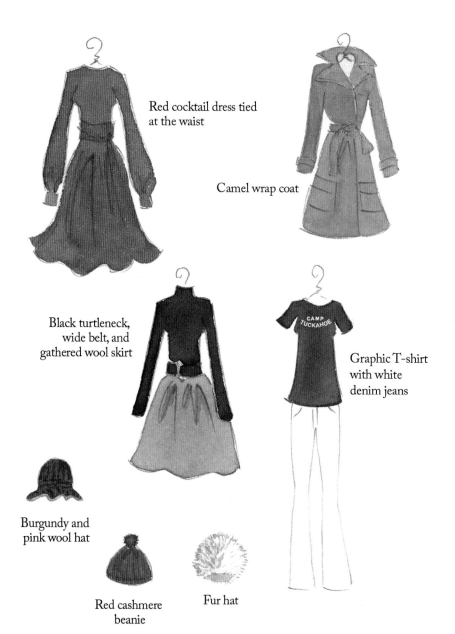

Red cocktail dress tied at the waist

Camel wrap coat

Black turtleneck, wide belt, and gathered wool skirt

Graphic T-shirt with white denim jeans

Burgundy and pink wool hat

Red cashmere beanie

Fur hat

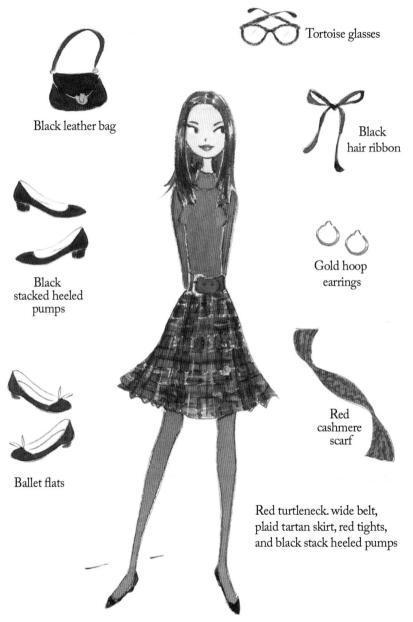

Tortoise glasses

Black leather bag

Black hair ribbon

Gold hoop earrings

Black stacked heeled pumps

Red cashmere scarf

Ballet flats

Red turtleneck. wide belt, plaid tartan skirt, red tights, and black stack heeled pumps

Mary Richards

ON THE REBOUND FROM A BREAKUP, MARY RICHARDS moves to Minneapolis to start a new life with a car full of ready-to-wear separates, polyester shirtdresses, knee-high boots, and, of course, the famous tam. On her surprisingly small TV associate producer's salary, she mixes and matches her wardrobe and cleverly accessorizes with wide belts, multiple chain necklaces, and colorful scarves. Mary sticks to the same beige color leather pumps with a stacked heel for most of her outfits, but sometimes throws in simple white sneakers for her casual looks and black Mary Janes for dates. While hosting one of her many disastrous parties, she stands out in a pink tied blouse and a long quilted maxi skirt with pink, orange, brown, and lavender patchwork. Once Mary is promoted from associate producer to producer, her hair gets shorter and her fashions change to more professional pantsuits, color-blocking sweaters, and skirts. Hey, Mary, who is the envy of every career gal? Well, it's you, girl, and you should know it.

The Mary Tyler Moore Show, 1970–1977
Mary Tyler Moore as Mary Richards
Costume Designer: Leslie Hall

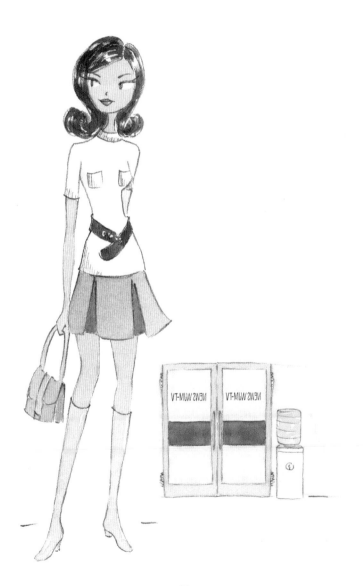

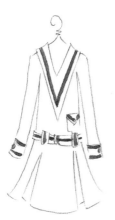

Sailor suit

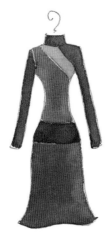

Colorblock
sweater and skirt

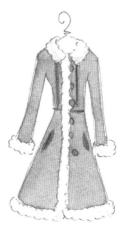

Shearling coat

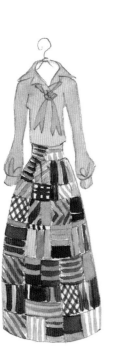

Tie blouse patchwork
and quilted maxi skirt

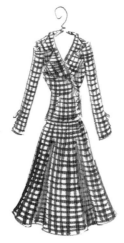

Gingham motorcycle
jacket and skirt

Spectator pumps

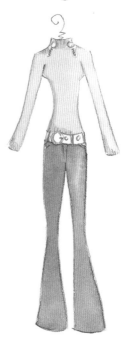

Double zipper tutleneck,
wide grommet belt,
and bell-bottom jeans

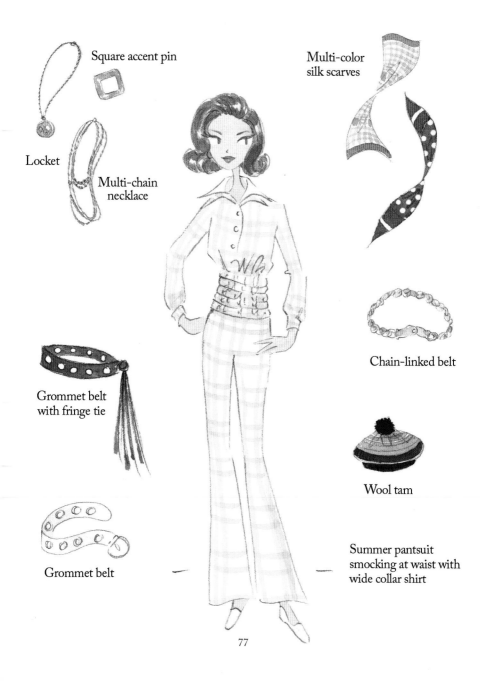

Square accent pin

Multi-color
silk scarves

Locket

Multi-chain
necklace

Chain-linked belt

Grommet belt
with fringe tie

Wool tam

Grommet belt

Summer pantsuit
smocking at waist with
wide collar shirt

Bree Daniel

LET'S START WITH BREE DANIEL'S ICONIC ANDROGYNOUS shag haircut that launched the popular hairstyle in the 1970s for both women and men. The aspiring actress/model and high-class call girl is more of a Park Avenue girl than the downtown-basement apartment dweller she had become. Her leather-trimmed trench coat with thigh-high boots, ruffled collars, and the shimmering form-fitting Norman Norell sequin dress with feather boa could still be worn today. She accessorizes her form-fitting turtlenecks and sweater tanks with chunky pendant necklaces, spiked leather chokers, and a hippy hobo fringed purse that matches every outfit. While walking the seedy streets with her detective/would-be lover, commingling with pimps and drug addicts, she maintains her sophisticated, mod urban style and lets it all hang out.

***Klute*, 1971**
Jane Fonda as Bree Daniel
Costume Designer: Ann Roth

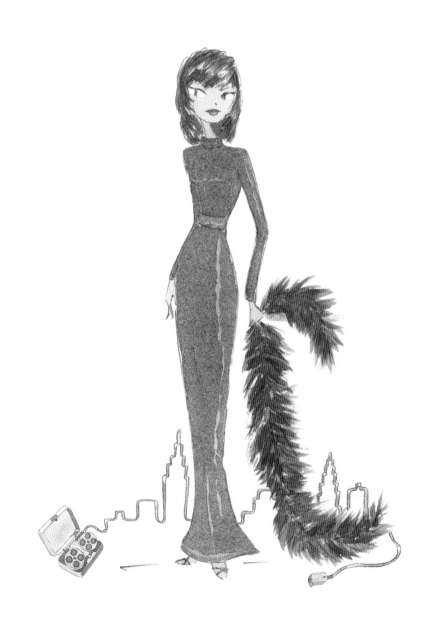

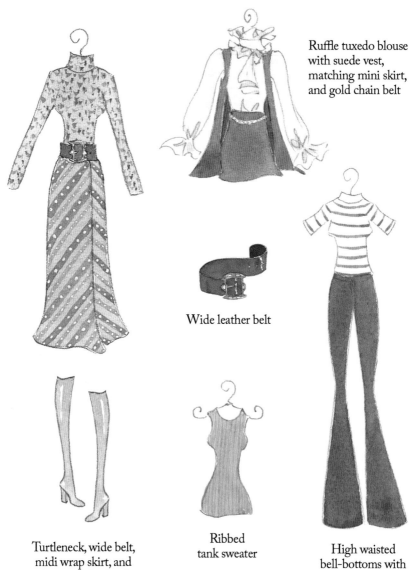

Ruffle tuxedo blouse with suede vest, matching mini skirt, and gold chain belt

Wide leather belt

Turtleneck, wide belt, midi wrap skirt, and matching gray leather boots

Ribbed tank sweater

High waisted bell-bottoms with striped T-shirt

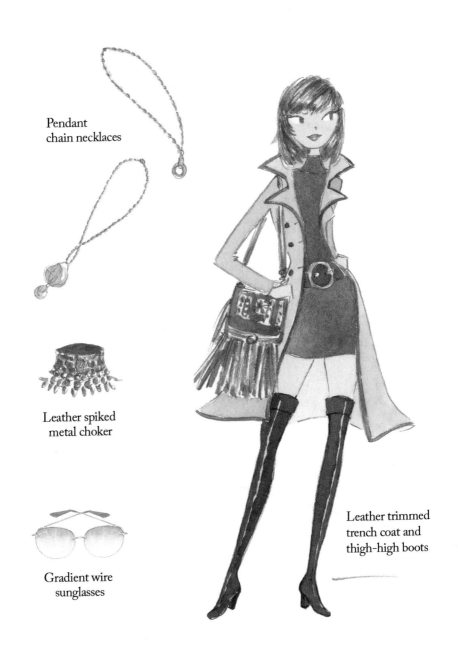

Pendant
chain necklaces

Leather spiked
metal choker

Gradient wire
sunglasses

Leather trimmed
trench coat and
thigh-high boots

Charlie's Angels

ONCE UPON A TIME, THREE ANGELS—JILL MUNROE, KELLY Garrett, and Sabrina Duncan—slip into their striped tank tops, skinny ribbed vests, and high-waisted flares, and become first-class private investigators. Jill, sporting bell-bottom jeans, Nike sneakers, and a red zip-up sweatshirt, hops on her skateboard and races off to safety after roughing up a shady character. With her flowing locks, she had women everywhere spending hours to achieve perfectly feathered hair. Kelly, the sensitive, streetwise angel, loves an off-the-shoulder top, white string bikini, and black motorcycle leathers. The brainy Sabrina favors scarf-accented turtlenecks, tie blouses, and pantsuits. This foxy trio dresses to kill, and along with their style and sass, they solve every case Charlie threw at them. "Thank you, Angels."

Charlie's Angels, 1976–1981
Jaclyn Smith as Kelly Garrett
Kate Jackson as Sabrina Duncan
Farrah Fawcett as Jill Munroe
Costume Designer: Nolan Miller

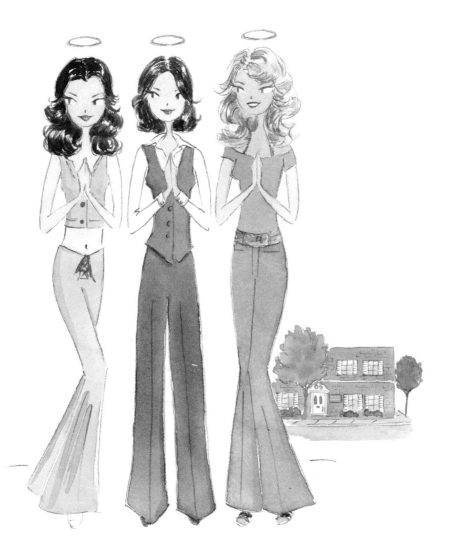

Foxy Brown

DO NOT MESS WITH FOXY BROWN, ESPECIALLY WHEN SHE'S wearing a pair of butterscotch studded-leather overalls and chasing down a couple of thugs in her badass Dodge Charger. When this streetwise beauty is out for revenge, she goes undercover as a high-class call girl and shows up for her interview in a red polyester cutout halter jumpsuit and a long, cascading wig. Instantly hired by the eccentric madam and her drug-dealing boyfriend, Foxy is ready for her first job in a powder-blue high-cut ruffled halter dress. And as she helps out a troubled coworker, she takes on a couple of mobsters in a burgundy short-sleeved jacket with matching skirt and orange psychedelic wide-collared shirt. After seducing a drug-smuggling pilot to take her to Mexico, she slips into high-waisted black leather bell-bottom pants, matching cropped leather coat, and hoop earrings. Foxy then pulls a gun out of her Afro and puts the prostitution and drug ring out of business. Superbad!

Foxy Brown, 1974
Pam Grier as Foxy Brown
Costume Designer: Ruthie West

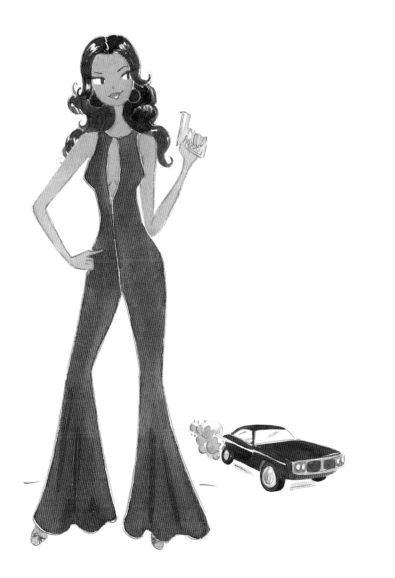

Annie Hall

THE ANNIE HALL LOOK IS A PREPPY VINTAGE MENSWEAR style that took over women's fashion in the late 1970s. The eccentric combination of neckties, vests, oversize jackets, and baggy khakis was found in Diane Keaton's own wardrobe, thrift shops, and men's stores. Annie and the romantically challenged Alvy Singer first meet on the tennis court, where she sees him after the match wearing a black bowler hat, necktie, white button-down shirt, and a black vest she got from her Grammy Hall. Annie, the master of layering, makes a simple rose-colored tank dress with a scarf belt look original. While celebrating her birthday, she puts together a look destined to resurface in the '90s—a spaghetti tank top over a simple T-shirt. When Annie and Alvy attend an L.A. party they swim in a sea of strapless dresses and too-tight T-shirts, but Annie stands out in a classic camel-colored suit. The relationship eventually ends, but all is forgotten when the two meet again years later, with Annie wearing a plaid shirt over a turtleneck, rolled up denim jeans, and her signature round tortoise sunglasses. La-di-da, La-di-da, la la.

Annie Hall, 1977
Diane Keaton as Annie Hall
Costume Designer: Ruth Morley

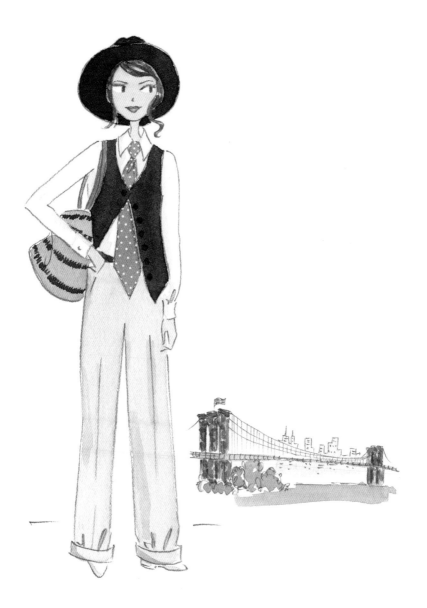

Alexis Carrington Colby

THE FIRST WOMAN TO BE CALLED A "BITCH" ON TELEVISION, Alexis Carrington Colby, the ex-wife of oil tycoon Blake Carrington, introduced a style that emblemized the 1980s trademark overindulgence, glitz, and glam. She makes her first appearance as a mystery witness testifying against her former husband in a dramatic black-and-white suit, wide-brim veiled hat, and dark sunglasses. It's all diamonds and champagne after that. Living a lavish lifestyle means every over-the-top getup Alexis wears does not disappoint. She intimidates with her linebacker-worthy shoulder pads, jewel encrusted gowns, and plush furs. She is the definition of "ultra-luxe," and everything about her glitters and shines—her dresses, jewelry, and even her metallic eye shadow. Whether she is in a catfight with Krystle or blackmailing a soon-to-be-ex, no one can ever ruffle the feathers adorning her highly accessorized sparkly gowns.

Dynasty, 1981–1989
Joan Collins as Alexis Carrington Colby
Costume Designer: Nolan Miller

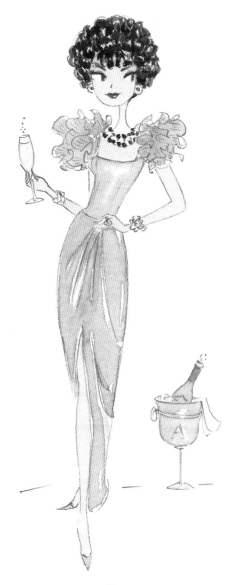

Susan

SUSAN, THE CONFIDENT, BLINGED-OUT, CHEESE DOODLE-munching freeloader, makes us all desperate for tied-up headbands, stacks of rubber bracelets, and parachute pants. She's first seen in an amazing green-and-gold metallic vintage coat with an embroidered pyramid on the back, but it is quickly traded in for a pair of silver-rhinestone-covered black boots. After she remembers she's left an important key in the coat pocket, Susan steps out in a lace cropped top over a black bra, layered rosary beads, and leggings to answer a personal ad from a "stranger" who will hopefully lead to her skull-patterned suitcase, which holds a stolen antiquity earring that belonged to Nefertiti. The meeting goes awry, but Susan gets a call while lounging in a bright orange head wrap, matching cropped T-shirt, and shorts layered over leggings that get her a bit closer to the key. Wearing a borrowed black sequin jacket, lace half gloves, red lipstick, a lace bodysuit, and leggings, Susan gets into a bit of a tussle, but is rescued by her beautiful stranger, and the two glam heroes make front-page news by turning over the Egyptian earrings to the authorities. "Good goin', stranger."

Desperately Seeking Susan, 1985
Madonna as Susan
Costume Designer: Santo Loquasto

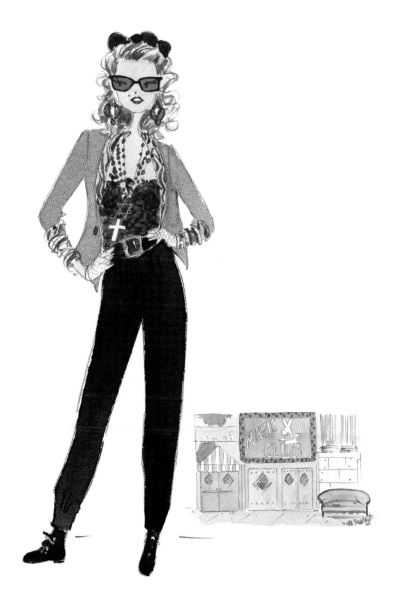

Vivian Ward

VIVIAN WARD STARTS OUT IN A BAD CAROL CHANNING-like wig, a cutout dress, and thigh-high boots with a safety pin keeping the zipper up. But her wardrobe is about to change when millionaire Edward Lewis picks her up in a Lamborghini, whisks her away to his hotel, and hires her for a week. Vivian's first shopping excursion doesn't go too well, but once hotel manager Barney steps in, she quickly turns from cheap to enchanting. In a white dress with black buttons, black hat, white gloves, and spectator slingbacks, she gets revenge on a pair of snobby Rodeo Drive saleswomen by buying up Beverly Hills and not spending a dime in their "very expensive" store. Edward takes Vivian to her first polo match in her signature brown polka-dot belted sleeveless dress, wide-brim hat, gloves, and beige pumps. She's brought to tears at the opera wearing a red chiffon evening gown, white gloves, and a ruby-and-diamond choker. Then when it looks like she may have lost her knight, "Princess Vivian" is rescued wearing a simple white tee, jeans, and navy blazer, and then gladly returns the favor as she rescues him right back.

Pretty Woman, 1990
Julia Roberts as Vivian Ward
Costume Designer: Marilyn Vance

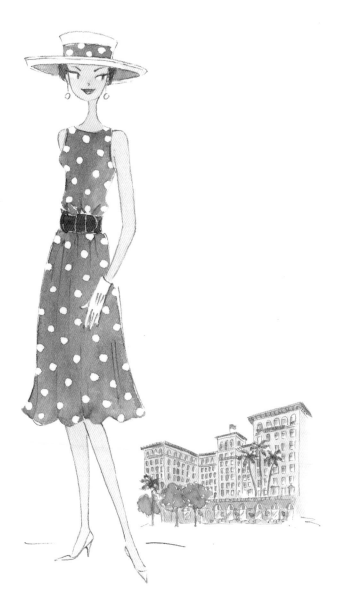

Mia Wallace

FEMME FATALE MIA WALLACE HAS A SIMPLE YET POWER-
ful style. The moment we see her with her bright red lips,
cropped black pants, and cuff links fastened to the French cuffs
of her classic fitted white shirt, we know she's really the tough-
est character in the male-dominated world of *Pulp Fiction*.
Mia's nail polish, Chanel "Vamp," became one of the best-sell-
ing colors in the world. With her Louise Brooks–reminiscent
black bobbed hair and Chanel gold slippers, she was the female
"reservoir dog." Even in her sleek, simple black swimsuit, swim-
ming robe, metallic gold swim cap, and black cat-eye sunglasses,
Mia evoked the high life and all things incredibly cool.

Pulp Fiction, 1994
Uma Thurman as Mia Wallace
Costume Designer: Betsy Heimann

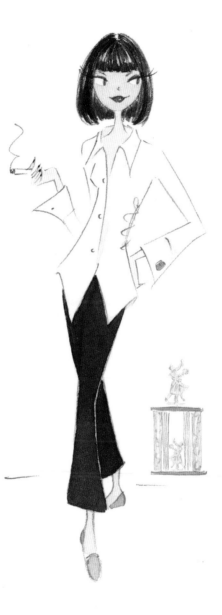

Cher Horowitz

THIS '90s HIGH-SCHOOLER PAVED THE WAY FOR GIRLY, innovative style. Never clueless when it came to fashion, she used her automated closet to put together unforgettable, fashion-forward outfits. A yellow tartan skirt suit combined with white thigh-high socks and Mary-Jane chunky heels kicked the grunge trend to the curb. Cher taught us to use a Polaroid camera to find the perfect ensembles and when it came to fashion, there was no such thing as "casual." A flannel, T-shirt, and baggy pants? As if! Her mission was to makeover the fashion-challenged, all the while keeping one's own individual style intact. She introduced a fresh upscale, preppy-chic to a whole new generation.

as if

***Clueless*, 1995**
Alicia Silverstone as Cher Horowitz
Costume Designer: Mona May

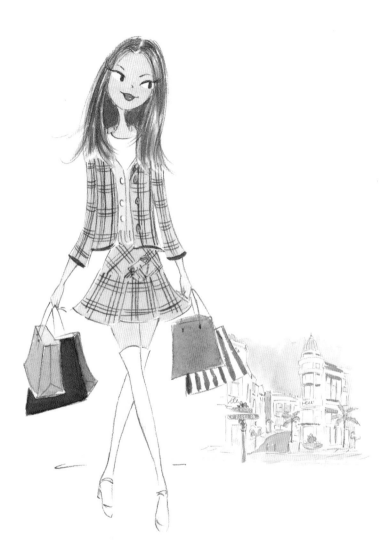

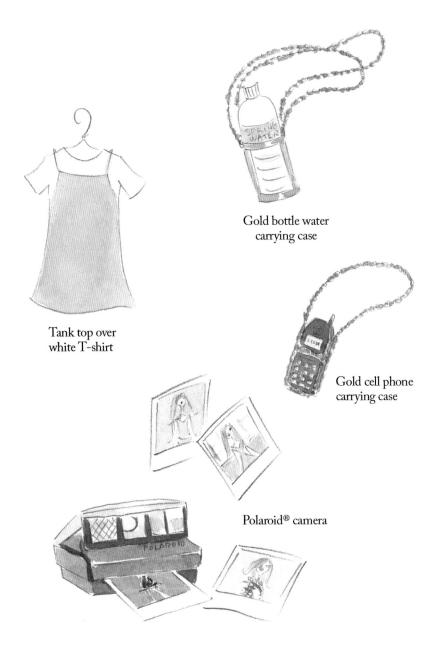

Gold bottle water
carrying case

Tank top over
white T-shirt

Gold cell phone
carrying case

Polaroid® camera

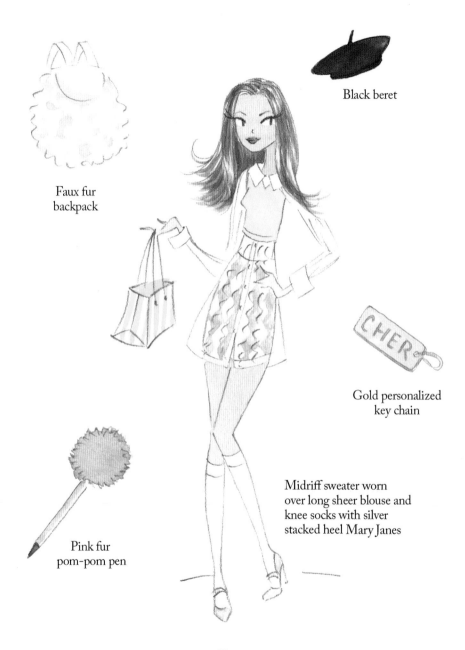

Black beret

Faux fur
backpack

Gold personalized
key chain

Pink fur
pom-pom pen

Midriff sweater worn
over long sheer blouse and
knee socks with silver
stacked heel Mary Janes

Carrie Bradshaw

ACROSS ALL SIX OF THE FASHION-RISK-TAKING SEASONS OF *Sex and the City*, Carrie Bradshaw wore everything from Manolo Blahniks to tutus, cropped tops to fur coats, and Gucci fanny packs to vintage Halston. As she typed up her weekly column, Carrie could be found in a sweatshirt, piled-on pearl necklaces, and classic stilettos paired with shorts. Known for spending an average $400 for a pair of shoes, Carrie was a woman who lived for fashion, and once confessed to "buying *Vogue* instead of dinner." When it comes to accessories, she made the Fendi Baguette the "it" bag, brought back personalized jewelry with her flea market "Carrie" gold necklace, and her most iconic accessory—a big flower pinned on everything from dresses to tank tops. Carrie Bradshaw was a fearless fashion leader, but above all she was a true friend, and this quote from her says it all: "They say nothing lasts forever; dreams change, trends come and go, but friendships never go out of style."

Sex and the City, 1998–2004
Sarah Jessica Parker as Carrie Bradshaw
Costume Designer: Patricia Field

Gucci fanny pack

Flower pin

Cosmopolitan

Lucky horseshoe
necklace

Manolo Blahnik Sedaraby
d'Orsay pump in silver

Fendi Baguette

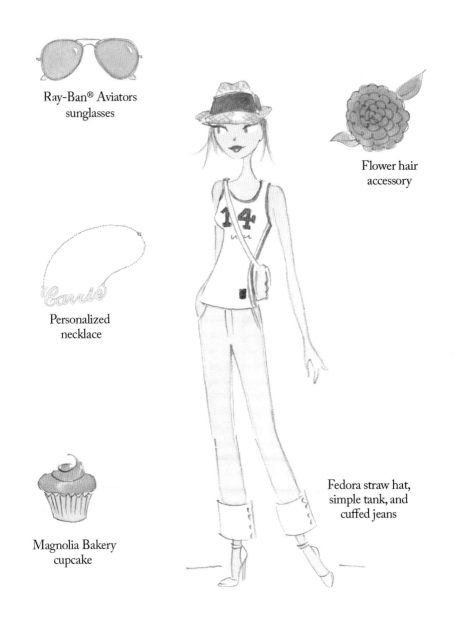

Ray-Ban® Aviators
sunglasses

Flower hair
accessory

Personalized
necklace

Magnolia Bakery
cupcake

Fedora straw hat,
simple tank, and
cuffed jeans

Galliano for Dior
newspaper print dress

Vintage muskrat
fur coat

Vintage ballerina dress

Oscar de la Renta

Dolce & Gabbana

Sonia Rykiel
striped sweater
with ruffle flower
and striped skirt

Manolo Blahnik

Dr. Scholl's

Chanel

Dior

Manolo Blahnik

Manolo Blahnik

Manolo Blahnik

Louboutin

Dior

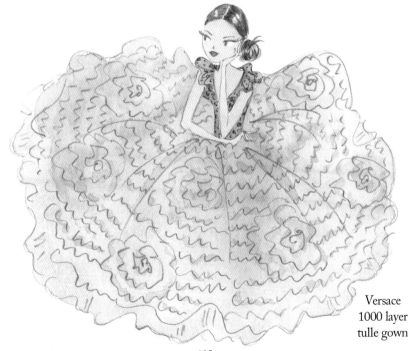

Versace
1000 layer
tulle gown

Andy Sachs

WHEN THE FASHION-CHALLENGED ANDY SACHS WALKS into the headquarters of *Runway* magazine in her "hideous skirt" and cerulean-blue Casual Corner sweater to start her first day as co-assistant for the publication's powerful editor-in-chief, Miranda Priestly, she's in for a rude awakening. It's quickly suggested that she replace her clunky black loafers with a pair of black Jimmy Choo slingbacks. For someone who can't spell Dolce & Gabbana, she quickly learns how fabulous it feels to slip into a Chanel coat, skirt, and a pair of buttery leather thigh-high boots. Andy is in deep when she finds out she just pushed out a coworker for attendance at Paris Fashion Week wearing a Chanel cap and black boat-neck sweater over a white Miu Miu shirt adorned with Chanel pearl logo multi-layer necklaces. Looking like a "vision," she glides into the event of the year in a Galliano gown and finally takes the breath away from her snobby coworkers. And when she realizes it's time to hang up her Louboutins, she settles into her own style, with jeans, a Vince leather jacket, and boots—"That's all."

The Devil Wears Prada, 2006
Anne Hathaway as Andy Sachs
Costume Designer: Patricia Field

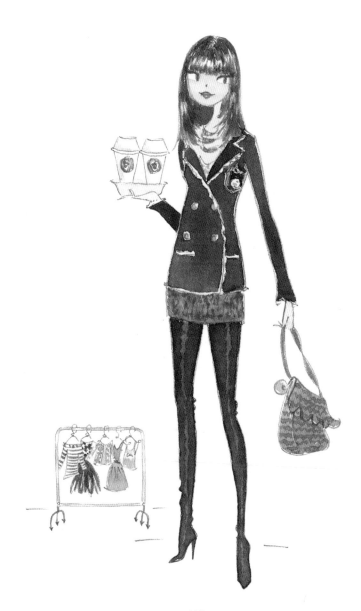

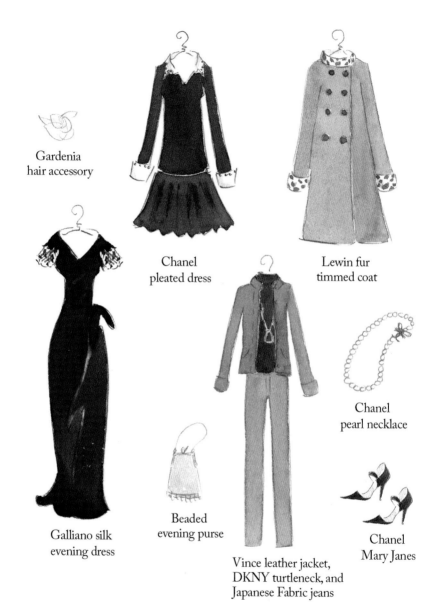

Gardenia
hair accessory

Chanel
pleated dress

Lewin fur
timmed coat

Chanel
pearl necklace

Galliano silk
evening dress

Beaded
evening purse

Chanel
Mary Janes

Vince leather jacket,
DKNY turtleneck, and
Japanese Fabric jeans

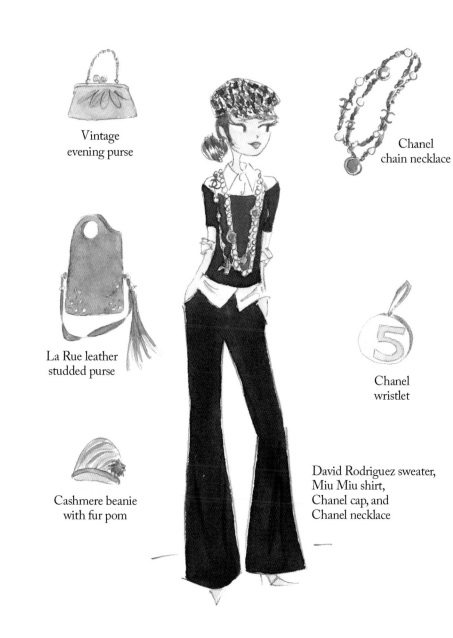

Vintage
evening purse

Chanel
chain necklace

La Rue leather
studded purse

Chanel
wristlet

Cashmere beanie
with fur pom

David Rodriguez sweater,
Miu Miu shirt,
Chanel cap, and
Chanel necklace

Betty Draper Francis

BETTY DRAPER FRANCIS, EX-WIFE OF THE DASHING DON Draper, isn't exactly going to win mother of the year, but her wardrobe should earn her a few awards. The superficial, privileged, beautiful former model has one sensational outfit after another—from the nip-waisted floral dress with a blue ruched taffeta sash to a frosty-blue fur-trimmed, three-quarter-sleeve brocade suit. We won't forget the moment when Betty hosts a dinner party and wears the infamous "sad clown" chiffon polka-dot dress with a blue-and-yellow sash. Ice-cold Betty, with a cigarette dangling from her mouth and BB gun locked and loaded, wears a lace nightgown and gossamer nylon robe as she shoots the neighbor's pigeons. On a quick business trip to Rome with Don, she transforms into an Italian starlet in a black crepe dress with fringe, a Chanel-like necklace, and an over the top up-do. And when Betty is given a dire diagnosis, she gives implicit attire instructions, which include a blue chiffon dress, her favorite lipstick, and an impeccable hairstyle. Only Betty would strive for fashion perfection after she's gone.

Mad Men, 2007–2015
January Jones as Betty Draper Francis
Costume Designer: Janie Bryant

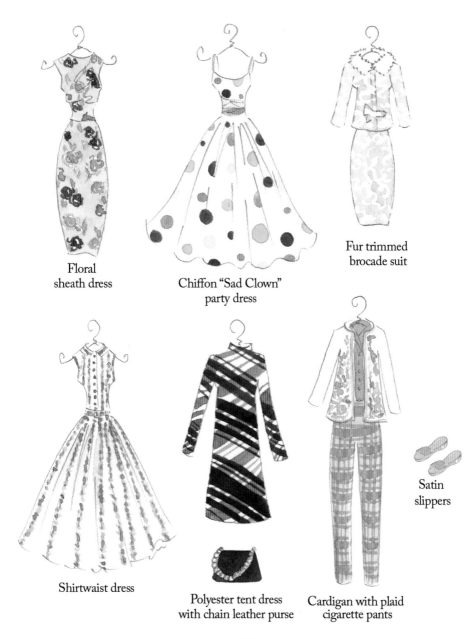

Floral
sheath dress

Chiffon "Sad Clown"
party dress

Fur trimmed
brocade suit

Shirtwaist dress

Polyester tent dress
with chain leather purse

Cardigan with plaid
cigarette pants

Satin
slippers

Butterfly
rhinestone
necklace

Floral sunglasses

Pearl cluster
earrings

White sunglasses

Pearl chain
necklace

White gloves

Single-strand
pearl necklace

Silk scarf with
ring pendant

Gold pumps

Up-do with bow barrette,
drop pearl earrings,
empire waist crepe dress,
and open toed pumps

Lady Mary Crawley

THE BEAUTIFUL, EYE-ROLLING LADY MARY CRAWLEY GAVE six spectacular and scandalous seasons of exquisite fashion, starting in the Edwardian era of nouveau empire waistlines and ending with the Jazz Age of drop-waist beaded dresses. One memorable frock is a corseted lace dress in black and navy with rows of velvet ribbons tied along each chiffon sleeve. Mary sparkles in a sunburst beaded tank dress as she considers her ruthless would-be-suitor, Sir Richard Carlisle. Realizing her true love is her distant cousin and heir to Downton, Matthew Crawley, she marries him in a lace tabard gown with long sleeves, tiny rice pearls, and a 45-carat diamond tiara securing her veil. Sadly, Mary loses Matthew, but when it's time to move on, she and Lord Gillingham meet in London to test their love, and she dons a fur-trimmed blue velvet coat and matching felt cloche hat. Holding court with old friends and soon-to-be husband, Henry Talbot, she stands out in emerald green, gold embroidery, metallic gold headband, and evening gloves. "Oh golly!"

Downton Abbey, 2010–2015
Michelle Dockery as Lady Mary Crawley
Costume Designers: Caroline McCall,
Anna Robbins, Susannah Buxton,
and Rosalind Ebbutt

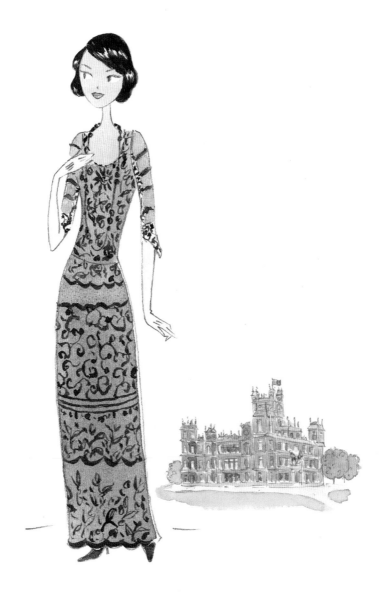

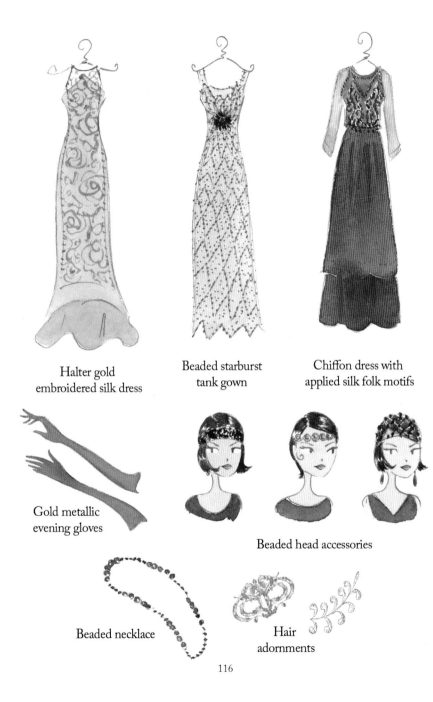

Halter gold
embroidered silk dress

Beaded starburst
tank gown

Chiffon dress with
applied silk folk motifs

Gold metallic
evening gloves

Beaded head accessories

Beaded necklace

Hair
adornments

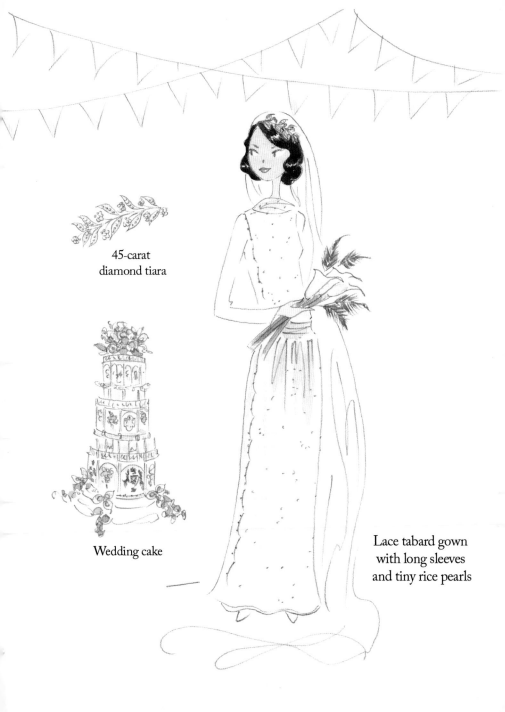

45-carat
diamond tiara

Wedding cake

Lace tabard gown
with long sleeves
and tiny rice pearls

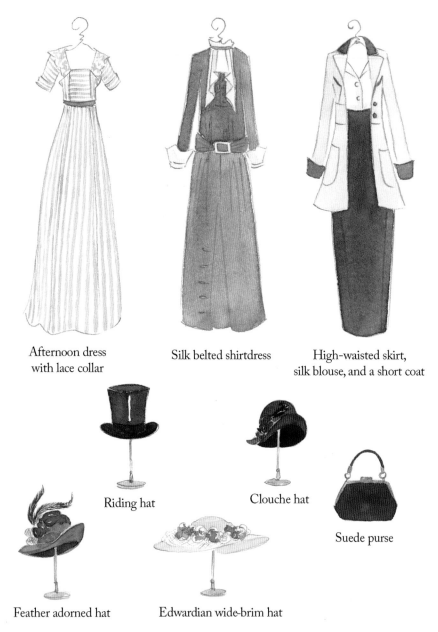

Afternoon dress
with lace collar

Silk belted shirtdress

High-waisted skirt,
silk blouse, and a short coat

Riding hat

Clouche hat

Suede purse

Feather adorned hat

Edwardian wide-brim hat

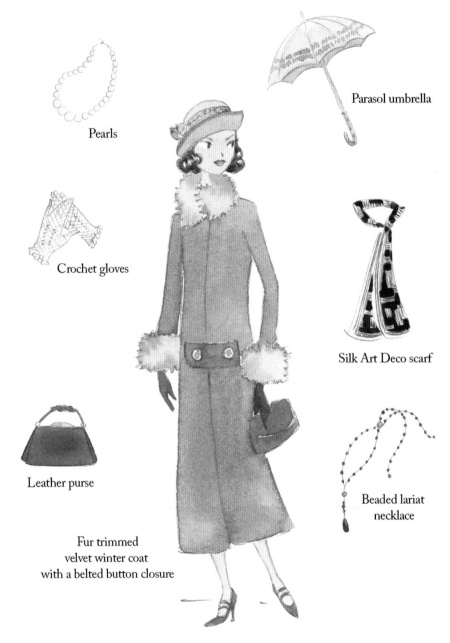

Pearls

Parasol umbrella

Crochet gloves

Silk Art Deco scarf

Leather purse

Beaded lariat
necklace

Fur trimmed
velvet winter coat
with a belted button closure

Olivia Pope

IMPECCABLY DRESSED, INTENSELY FIERCE, AND "THE FIXER" of countless Washington, D.C., scandals, Olivia Pope's style and grace have her on endless best-dressed lists. This "gladiator" breaks away from the dull D.C. "uniform" of dark conservative suits with her lighter tone separates of Armani, Stella McCartney, Michael Kors, and Dior. With the soft draping of an overcoat or the unexpected detail of a suit jacket, she still looks perfect in spite of her own complicated personal life. When attending a tragic birthday party of her not-so-secret lover, the president, Olivia stands out in a Jean Fares white strapless beaded gown and matching clutch. Overall, her accessories are minimal—elbow-length gloves, a Prada tote bag, and, of course, the iconic Louise Green winter white fedora. After a typical day of cleaning up other people's messes, Olivia—in a Donna Karan cashmere sweater, La Perla silk pajama bottom, and sipping on her signature glass of red wine—can confidently say, "It's handled."

Scandal, 2012–
Kerry Washington as Olivia Pope
Costume designer: Lyn Paolo

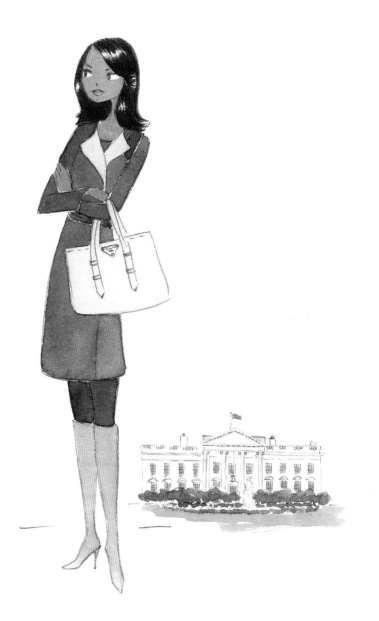

Cookie Lyon

THE MATRIARCH COOKIE LYON HAS BEEN COMPARED TO *Dynasty*'s Alexis Carrington Colby, but with a fierce, flashy style that is all her own. With her gold lamé suit, furs, leopard, and zebra outfits, she pulls off looks that a lot of us can only dream of. She can change her hairstyle almost as fast as her Versace, Chanel, and Gucci ensembles. Cookie brought back the fedora, applies lipstick shades to match her furs, and is never one to skimp on bejeweled accessories. Her bedazzled talon nails launched a new line of nail polish that's bound to make anyone feel as badass as Cookie. And her six-inch Louboutin stiletto heels can—and will!—kick anyone's ass that messes with her family and/or her recording business. Cookie, "You're So Beautiful."

Empire, 2015–
Taraji P. Henson as Cookie Lyon
Costume Designers: Rita McGhee
and Paolo Nieddu

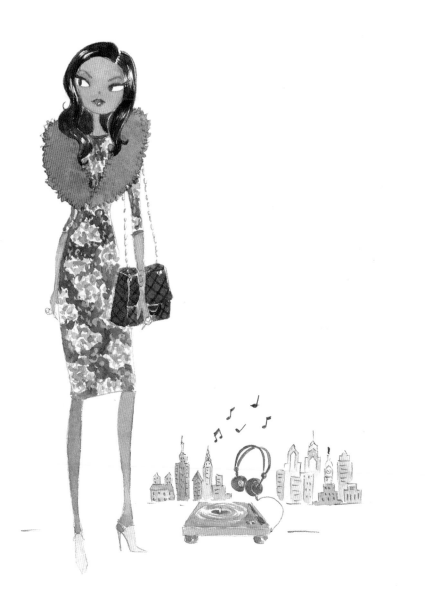

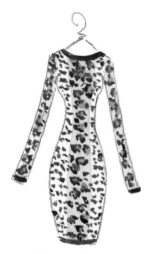

Leopard print
Red Valentino dress

Louboutin clutch

Philip Treacy fedora

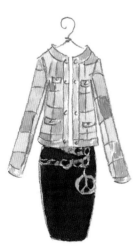

Moschino
ensemble

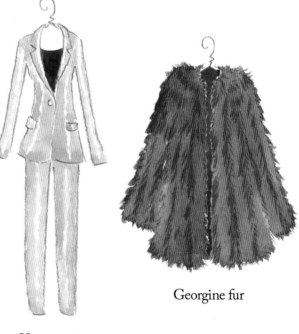

Versace suit

Georgine fur

Prada
crystal sunglasses

Deborah Lippmann
Cookie-inspired
nail polish

Gold crystal
iPhone case

Dita cat-eye
sunglasses

Mixing up top designers:
Versace, Jimmy Choo
and Louboutin

ACKNOWLEDGMENTS

FIRST AND FOREMOST, I WOULD LIKE TO THANK MY talented editor, Cindy De La Hoz, who championed this dream project and turned it into a reality. Amanda Richmond, a gifted designer who helped me design this book. My incredibly steadfast, supportive, and creative agent, Fran Black. Jason, for his love and endless support. Diane Keaton for her gracious quote and my sister-in-law, Liz Keenan. My compassionate and understanding family and friends. The valuable librarians at the Bloomfield Township Public Library. The films and television shows that gave life to these fabulous characters. All the innovative and influential costume designers. The brilliant actresses who shaped the characters they portrayed. Lastly, and to name just a few, the ingenious fashion designers who always amaze and inspire me: Yves Saint Laurent, Coco Chanel, Givenchy, Dior, Oscar de la Renta, Dolce & Gabbana, Versace, Manolo Blahnik, and Roger Vivier.

Tom Roche

ANNE KEENAN HIGGINS began her career as an art director for advertising agencies in Detroit after earning her degree from the University of Michigan. Later starting her own illustration business, Anne developed a signature whimsical style and began licensing her artwork. She has illustrated over 100 book covers, including Sophie Kinsella's *Shopaholic* series. Anne resides in Detroit, Michigan.